Create
+
DESTROY

240 pages of fun and
creative tasks to complete!

Follow us on social media!

Tag us and use #piccadillyinc in your posts
for a chance to win monthly prizes!

10 9 8 7 6 5 4 3 2 1

Printed in China

ISBN-13: 978-1-60863-922-9

MAKE A WELCOME PAGE TO YOURSELF AND DESCRIBE IN DETAIL LITTLE THINGS YOU'RE LEARNING ABOUT YOURSELF. DECORATE THE PAGE IN ANY WAY YOU WANT OR KEEP IT SIMPLE.

GAME TIME

MAKE THIS PAGE LOOK LIKE A PINBALL MACHINE OR YOUR FAVORITE VIDEO GAME

PUNCH HOLES AN INCH APART ALONG THE EDGES OF THIS PAGE. THEN TAKE COLORFUL YARN OR RIBBON AND WEAVE IT THROUGH THE HOLES. TIE A BOW WITH THE ENDS.

Beehive design this entire page and write fun facts about bees. Bonus points if you can work honey into this page!

SELFiE TIME! FiLL THIS SPREAD WITH YOUR FAVORITE SELFIES AND BE SURE TO ADD PERSONAL DECORATIVE TOUCHES.

ON THESE PAGES

Make a treasure map on these pages.

Remember that X marks the spot in RED.

GiVE THIS PAGE A **SPLIT PERSONALITY** BY DIVIDING IT IN HALF AND MAKING EACH HALF

OPPOSITE OF THE OTHER PAGE. THERE ARE NO RULES EXCEPT BE AS CREATIVE AS POSSIBLE.

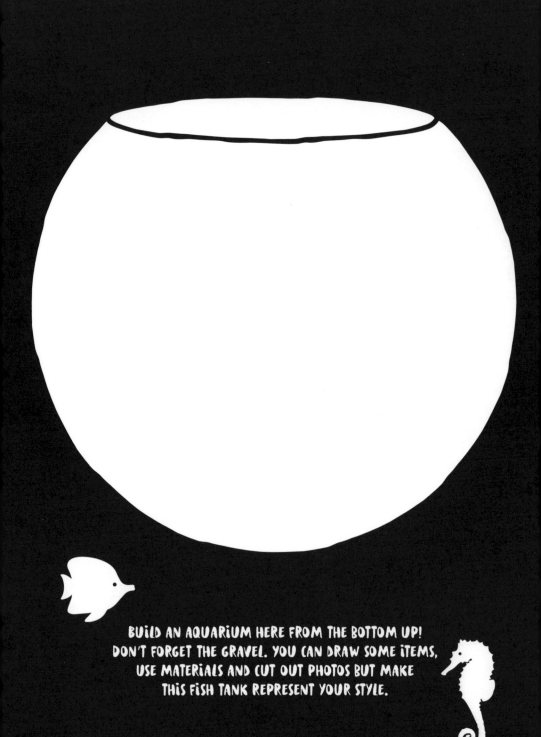

BUILD AN AQUARIUM HERE FROM THE BOTTOM UP!
DON'T FORGET THE GRAVEL. YOU CAN DRAW SOME ITEMS,
USE MATERIALS AND CUT OUT PHOTOS BUT MAKE
THIS FISH TANK REPRESENT YOUR STYLE.

B I N G O

B	I	N	G	O
3	11	5	55	26
70	36	26	1	9
48	17	THIS PAGE IS FOR A **BINGO** GAME IN PROGRESS. BE SURE TO MARK NUMBERS ALREADY CALLED!	8	34
57	69	25	63	59
35	27	10	22	52

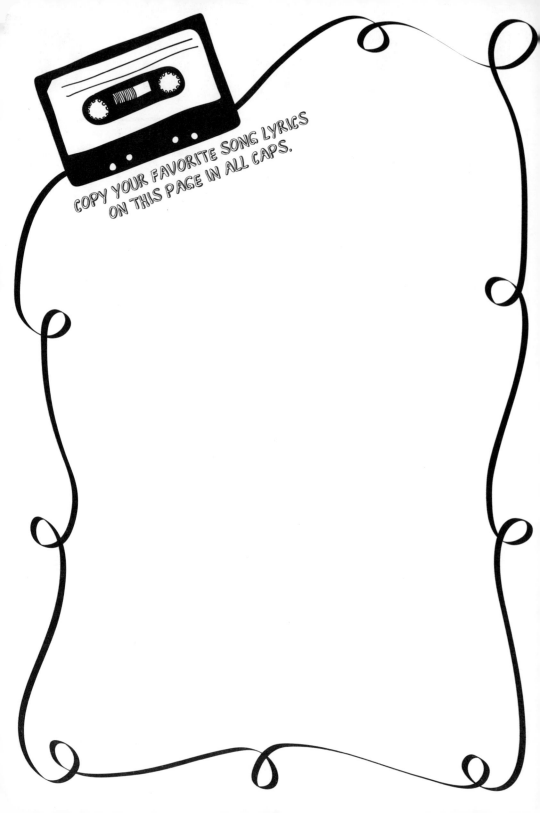

COPY YOUR FAVORITE SONG LYRICS ON THIS PAGE IN ALL CAPS.

THIS PAGE IS A "STRESS RELIEF" PAGE! LIST YOUR STRESS RELIEVERS ON THIS PAGE.

PAGES OF FORTUNE

GO TO VARIOUS CHINESE RESTAURANTS
AND ASK FOR FORTUNE COOKIES. THEN
TAPE ALL THE FORTUNES YOU COLLECT
TO THESE PAGES.

BREAK PIECES OF OLD DVDs,

RECORDS, OR PLASTIC MATERIALS,

AND CREATE AN ARTSY COLLAGE.

Antique this page. Make it look old by staining it, wrinkling it and even damaging the edges. Put something in the center of this page you love that is vintage.

TRANSFORM THIS PAGE INTO AN EASTER EGG PATTERN.

Use cardboard on this page in an interesting way!!

USE THESE PAGES AS A CHALKBOARD.

USE CHALK TO WRITE A POSITIVE MESSAGE TO YOURSELF.

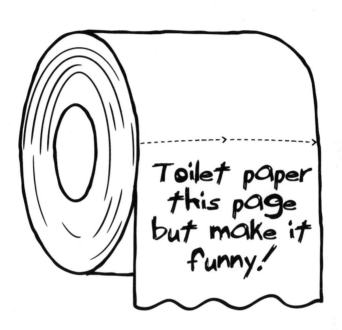

CREATE YOUR OWN SOLAR SYSTEM HERE...
YOUR PLANETS, YOUR GALAXY AND YOUR DESIGN.

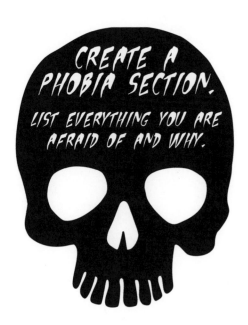

WRITE YOUR NAME IN TOOTHPASTE ON THESE PAGES.

DECORATE THIS PAGE LIKE A DONUT AND DON'T FORGET THE SPRINKLES!

Take a photo of your journal and then tape the photo to this page. Draw lightning bolts around all sides.

CREATE A GARDEN ON THESE PAGES. BE SURE TO INCLUDE DIRT, SOMETHING GREEN, AND

GLUE DIFFERENT SEEDS IN THE SOIL. DRAW ABOVE GROUND WHAT THE SEED WILL BECOME.

WRITE A POEM DIAGONALLY
ON THIS PAGE.

DRAW A
CEMETERY
ON THESE
PAGES AND FILL
IT WITH DEAD
THINGS. BUGS
COUNT SO
DON'T GET
CREEPED
OUT!

Create a bullseye and use it for target
practice. Throw anything you want at it.
Bonus points if you hit the center.

Staple the edges of this page to create a border.

DECORATE THIS PAGE LIKE YOUR FAVORITE HOLIDAY. MAKE iT POP WITH ALL THE COLORS AND SYMBOLS THAT REPRESENT THE HOLIDAY. USE DIFFERENT TEXTURES TO CAPTURE THE MOOD.

DRAW A BIG TENNIS SHOE. NEXT TIME YOU CHEW GUM AND
YOU'RE DONE, STICK IT TO THE BOTTOM OF THIS SHOE. TRY
AND GET AS MANY COLORS OF GUM YOU CAN.

CREATE YOUR OWN SHEET MUSIC ON THESE PAGES.

DON'T FORGET TO TITLE YOUR SONGS.

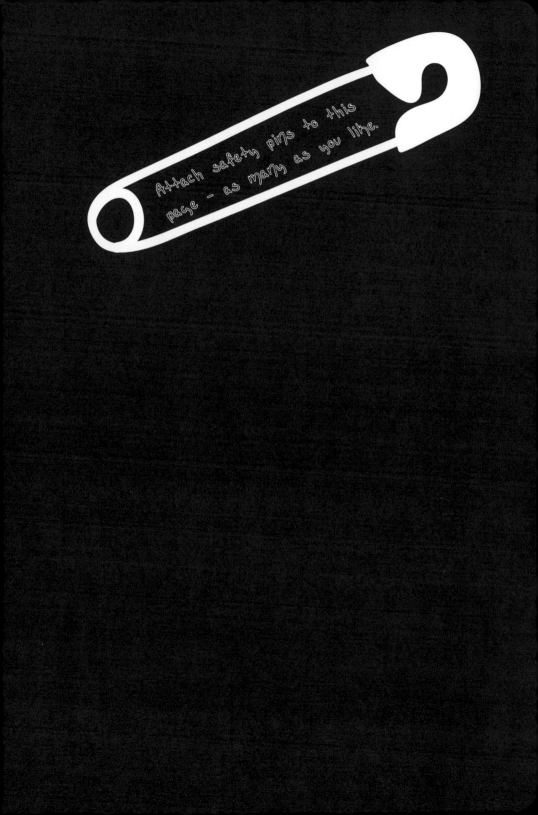

Attach safety pins to this page - as many as you like.

THIS PAGE WITH KETCHUP, MUSTARD, RANCH, OR WHATEVER YOU LOVE...

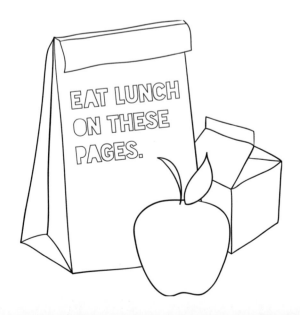

EAT LUNCH
ON THESE
PAGES.

Create a polish spread.
Write the alphabet in shoe polish or nail polish.

Create your own original board game on these pages. Use
materials you find around you house to make the game more realistic.

MAKE THiS PAGE FEEL PRiCKLY.

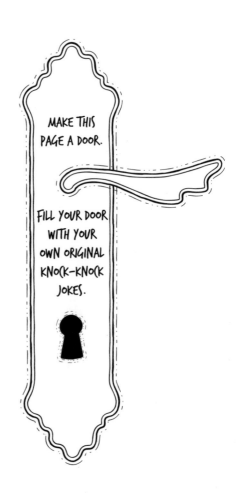

MAKE THIS PAGE A DOOR.

FILL YOUR DOOR WITH YOUR OWN ORIGINAL KNOCK-KNOCK JOKES.

Ask a friend or
neighbor to write
you a note on
these pages.

CREATE A "NOTE TO SELF" PAGE.
Write down things you would want to read 10 years from now.
Create important notes to carry throughout your life.

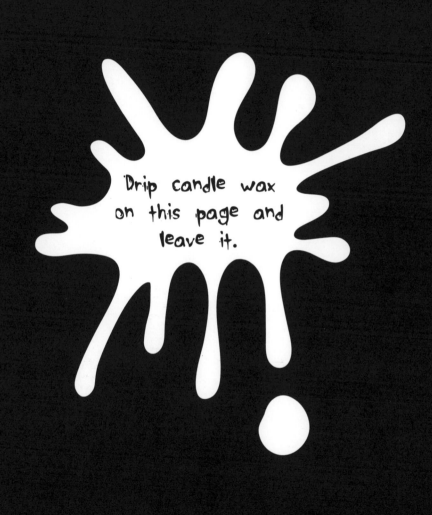

Drip candle wax on this page and leave it.

THIS PAGE IS **HIGH FASHION.**

CUT OUT AND PASTE SWATCHES OF DIFFERENT FABRICS
AND MATERIALS TO CREATE RUNWAY READY CLOTHING.

MAKE THIS PAGE ALL ABOUT FEATHERS. FIND AS MANY
DIFFERENT FEATHERS AS YOU CAN AND LABEL EACH ONE.
BE CREATIVE HOW YOU APPLY THE FEATHERS.

Get different cookie cutters and trace their shapes on this page. Make them come to life by adding character.

YOU'RE A
FORCE OF NATURE

TRANSLATE WHAT THAT LOOKS LIKE BELOW...

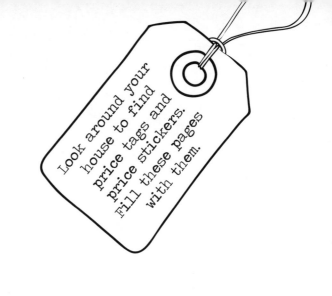

Look around your
house to find
price tags and
price stickers.
Fill these pages
with them.

SMEAR
SOMETHING
GLOSSY
HERE.

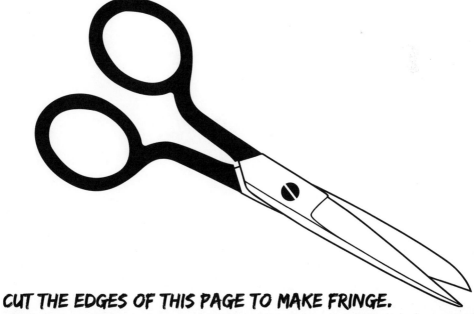

CUT THE EDGES OF THIS PAGE TO MAKE FRINGE.

Bake something with someone you love.
Splatter this page with ingredients you used
and tape a few of the ingredient labels.

USE A HAMMER AND CRUSH DIFFERENT COLORFUL THINGS (CRAYON, CHALK, FLOWERS) ALL AROUND THIS PAGE. TRY TO MAKE A PAINTING USING ONLY THE HAMMER AND THINGS YOU SMASH!

THIS IS THE 24-KARAT GOLD PAGE.
FILL THIS SECTION WITH ANYTHING
AND EVERYTHING GOLD IN COLOR.

THIS IS YOUR WEEKEND MORNING SPREAD. FILL THIS PAGE WITH THINGS YOU LOVE ABOUT WEEKEND MORNINGS.

CREATE A CABIN IN THE WOODS USING

POPSICLE STICKS AND YOUR IMAGINATION.

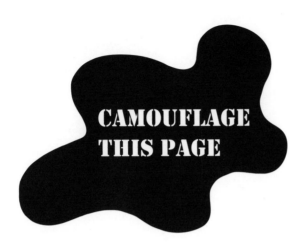

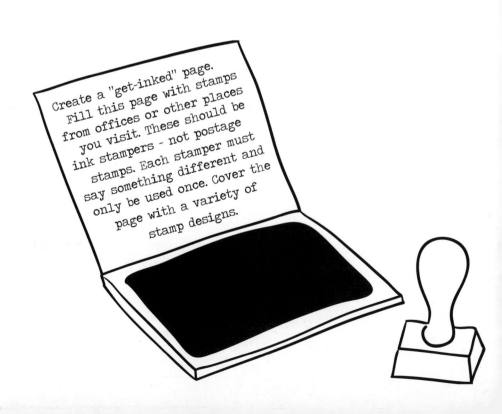

Create a "get-inked" page. Fill this page with stamps from offices or other places you visit. These should be ink stampers - not postage stamps. Each stamper must say something different and only be used once. Cover the page with a variety of stamp designs.

This is a page of layers.

Create as many fun and interesting layers as you can

This could take some time.

Create a
lost and found
page here...

Write about
things you've found &
things you've lost.

Conduct a science experiment on this page.

Turn back to these pages when you feel like crying. Write down what made you cry. Then let your tears wash over the ink as they fall.

Cut words out of magazines, books, mail or anything you find and create a story. Each word has to be cut from a NEW source. Take your time and build a good story.

GO OUTSIDE YOUR HOUSE AND GATHER THINGS
THAT REPRESENT WHERE YOU LIVE AND YOUR
NEIGHBORHOOD AND PASTE THEM HERE.

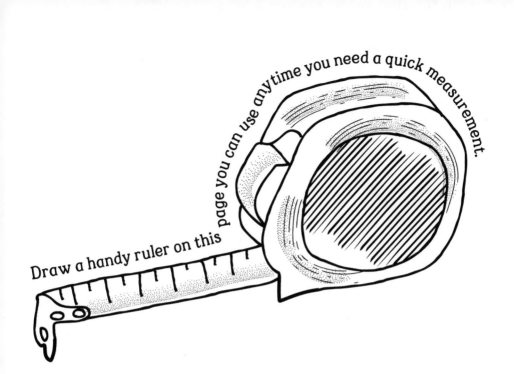

Draw a handy ruler on this page you can use anytime you need a quick measurement.

GONE FISHING!

DRAW AN AWESOME FISH IN THE CENTER OF THIS PAGE.
FILL THE EDGES WITH LURES, HOOKS AND OTHER FISHING
MATERIALS. HAVE FUN AND GO WILD!

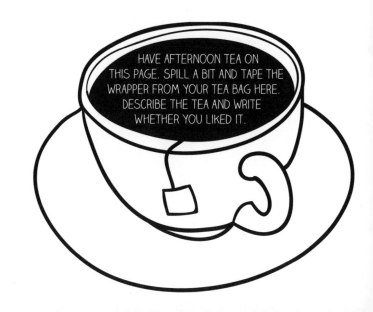

HAVE AFTERNOON TEA ON
THIS PAGE. SPILL A BIT AND TAPE THE
WRAPPER FROM YOUR TEA BAG HERE.
DESCRIBE THE TEA AND WRITE
WHETHER YOU LIKED IT.

UP, UP, AND AWAY!

DRAW YOUR MOST CREATIVE HOT AIR
BALLOON. USE REAL ROPE AND BASKET
MATERIALS FOR THE BOTTOM THAT WILL
ATTACH TO THE BALLOON YOU CREATE.

Create a **Collection** spread. Collect something

that's unusual, small, and flat. Paste your collection on these pages.

Write a secret message you don't want anyone to read. Then cover the entire page with your fingerprints. Be sure to ink all your fingers and finish the whole page.

YOUR CURRENT MOOD...

Be
completely
random
right
here.

LEAVE THIS SPREAD OPEN OUTSIDE OVERNIGHT AND SEE WHAT HAPPENS.

YOU CAN REPEAT THE PROCESS MORE THAN ONE NIGHT IF YOU WANT TO.

Collect business cards from places you like. Tape them on these pages and keep collecting until the entire two pages are full.

MAKE THIS SPREAD
FEEL LIKE A DAY AT
THE POOL. COVER iT
WiTH THINGS YOU'D
HAVE POOLSIDE AND DON'T
FORGET THE SUNSCREEN. INCLUDE A
DRAWiNG OF AN EPiC POOL FLOATiE.

CLIP SOME BUTTONS OFF OF ANYTHING AND GLUE THEM HERE.

THIS IS THE GREEN PAGE.

**GLUE OR TAPE AS
MANY DIFFERENT
GREEN THINGS
AS YOU CAN FIND
TO THIS PAGE.**

COLOR THIS PAGE USING ONLY HIGHLIGHTERS.

Create something using foil on this page.

Give this page a haircut.

MAKE THIS PAGE FULL OF PASTABILITIES AND PASTE DIFFERENT SHAPES OF DRIED PASTA HERE! THE MORE KINDS YOU FIND, THE BETTER!

Make this page *glow* in the dark!

Do something cool with shoelaces by weaving it in and out of the page or make a shoelace border. Whatever you want to do. Use as many shoelaces as you want.

SPREAD THE LOVE PAGE. WRITE KIND MESSAGES ON EACH STRIP AND TEAR THEM OUT. GIVE THEM TO PEOPLE WHEN THEY NEED TO BE (HEERED UP

MAKE THIS PAGE A SMILEY FACE BY POKING HOLES IN IT WITH DIFFERENT SHARP OBJECTS.

summer of

Fill in the year of the summer you complete this. Collect
a memory or item from every place you visit for an entire
summer and create a scrapbook on these pages.

SCARY CLOWN PAGE
MAKE THIS AS REAL AS POSSIBLE BY ADDING CLOWN MAKEUP, HAIR OR WHATEVER ELSE CLOWN NIGHTMARES ARE MADE OF!!!

Collect postage stamps on this page.

Get spicy and make a collection of spices any chef would love. Make circles of glue, then sprinkle different spices you find and label each spice by name.

On this spread, put
SOMETHING OLD
& SOMETHING NEW
that have a special meaning to you.
Write what each item means to you next to it.

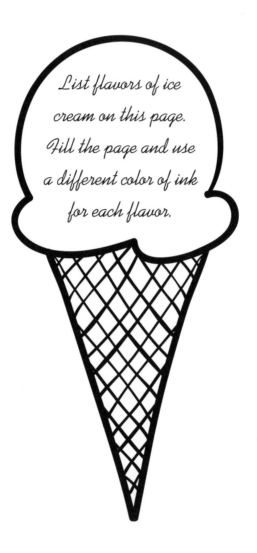

List flavors of ice cream on this page. Fill the page and use a different color of ink for each flavor.

Make a scratch-and-sniff page here.

MAKE THIS PAGE LOOK LIKE AN ALIEN LANDED HERE.

MAKE THIS PAGE LOOK LIKE LIGHTNING HIT IT.
CREATE A STORM!

FILL THESE PAGES WITH SOUR THINGS.

USE LEMON IN A CREATIVE WAY!

COVER THESE PAGES WITH STRIPS OF TAPE.

YOU CAN USE DIFFERENT KINDS OF TAPE.

TAKE PUZZLE PIECES FROM DIFFERENT PUZZLES AND MAKE SOMETHING AWESOME. DESCRIBE WHAT YOU MADE.

Take these pages outside when it rains,
use it as an umbrella.

Then go inside and write about how you felt in that moment. Yes, the page will still be wet.

Create a stain log. Smudge up each box with a different stain but be sure to write what the stain is in each box. Anything goes!

♥ ♥ ♥ ♥ ♥ ♥ ♥ ♥ ♥ ♥ ♥ ♥ ♥ ♥ ♥ ♥ ♥

show the

LOVE
♥ ♥ ♥

write down all
the things
you love
here.

♥ ♥ ♥ ♥ ♥ ♥ ♥ ♥ ♥ ♥ ♥ ♥ ♥ ♥ ♥ ♥ ♥

CREATE A ROLLER COASTER ON THIS PAGE.

FILE THIS PAGE WITH A FINGERNAIL FILE.

THIS PAGE HAS A SWEET TOOTH. FILL IT WITH YOUR FAVORITE CANDY AND GUM WRAPPERS AS YOU FINISH THEM.

FILL THIS SPREAD WITH AS MANY DIFFERENT STICKERS AS YOU CAN. DON'T OVERLAP SO YOU CAN SEE EACH STICKER. CREATE A THEME THAT REPRESENTS YOU!

Play ball on these pages (tennis, basketball, Ping-Pong, etc.). Oh, and be sure to get the ball muddy.

CREATE THE BIGGEST FLAT BALL OF YARN FOR KITTENS TO PLAY WITH. P.S. DON'T FORGET

THE KITTENS. IT'S OK IF THE YARN DANGLES OFF THE PAGE...

THIS IS YOUR SPREAD OF WISHES. IT'S JUST FOR YOU,
SO DECORATE IT ANYWAY YOU WANT BUT WRITE ALL
YOUR WISHES ON THESE PAGES. ANYTIME YOU
HAVE A NEW WISH, ADD IT TO THESE PAGES!

MAKE THIS ENTIRE PAGE A BOOKMARK
AND DON'T FORGET THE TASSEL.

THIS PAGE SHOULD LOOK LIKE UNICORN POOP!
DON'T HOLD BACK...

Make this page a tribute to yourself but only write in calligraphy! Write down all the compliments people have given you. Write in random sizes and directions but only in calligraphy.

TAPE A PICTURE OF SOMEONE
WHO INSPIRES YOU AT THE
CENTER OF THE PAGE.

THEN WRITE WORDS TO
DESCRIBE HOW THEY MAKE YOU
FEEL ALL AROUND THEIR PHOTO.

THIS PAGE IS SO SQUARE... BECAUSE YOU'RE GOING TO LAYER THIS PAGE WITH AS MANY SQUARE THINGS AS YOU CAN FIND.

DO SOMETHING WITH OLD SOCKS ON THIS PAGE. BE SURE
THEY DON'T STINK! A SOCK PUPPET MIGHT BE FUN.

MAKE THIS PAGE
WALL-TO-WALL
DOODLING!

Share this section with a friend and let them decide what to do with the page.

Get GROOVY and tie dye this page.
Make it psychedelic, bold and colorful.
A little bit of neon wouldn't hurt.

F.R.E.E

·B·I·E·S

CREATE TRACKS ON THIS PAGE WITH PATTERNS FROM THE
BOTTOMS OF DIFFERENT SHOES. USE DIFFERENT COLORS
AND TRY TO GET AS MANY DIFFERENT
PATTERNS AS YOU CAN.

CREATE A WALL OF **GRAFFITI** ON THIS PAGE
SPRAY PAINT IS ALLOWED!

MAKE SOMETHING **COOL** ON THESE PAGES USING ONLY FREE SAMPLES YOU FIND (SUCH AS FREE PAINT SWATCHES FROM A HARDWARE STORE).

MAKE THIS PAGE LOOK LIKE A SHARK ATTACKED IT!

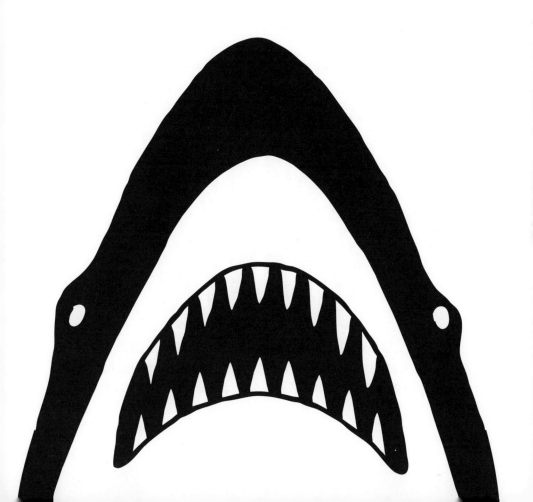

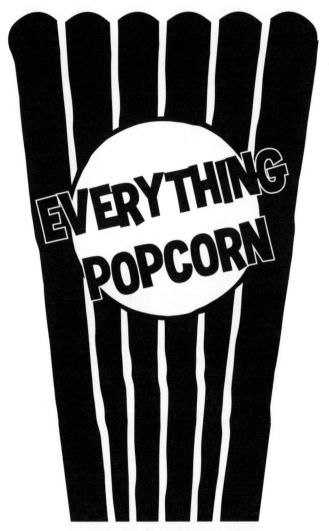

Decorate this page with EVERYTHING POPCORN.
Kernels, popped corn, toppings and anything that has
to do with popcorn. It should look like popcorn exploded!

OH SNAP!
Tie a ribbon or string to the corner of the page as your reminder page. Write down things on this page you're always forgetting!

THIS PAGE IS NOW YOUR LOCKER... WHAT'S INSIDE?
DON'T FORGET TO INCLUDE THE COMBINATION TO YOUR LOCK USING
NUMBERS IN A CREATIVE WAY! THE MORE MATERIALS YOU USE, THE BETTER!

HAVE EACH OF YOUR
FRIENDS COLOR THEIR HAND WITH
INK, MARKER OR PAINT. LEAVE A
HANDPRINT OR A PAW PRINT
FROM YOUR PET.

 HAVE A RACE BETWEEN A MARKER AND PEN.
WRITE WHO WINS AND WHY.

Cover these pages with squiggly lines, lines, and more lines.

CREATE A NEW INVENTION. DESCRIBE IT.

MAKE A "FEEL GOOD" PAGE WITH POSITIVE QUOTES.

FILL IN THESE PAGES COMPLETELY WITH PENCIL. LEAVE NO SPACE BLANK. THEN TAKE AN ERASER AND ERASE OUT A FUN PICTURE.

DRAW THE FACE OF A PUPPY OR KITTEN.

Turn this page into the sky. Don't forget the clouds
(hint: cotton balls) and make it look like your ideal day.

MAKE THESE PAGES LOOK LIKE A SPIDER WEB.
FILL THE ENTIRE SPACE.

MAKE THIS PAGE ECHO.

 MAKE THIS PAGE ECHO.

 MAKE THIS PAGE ECHO.

 MAKE THIS PAGE ECHO.

 MAKE THIS PAGE ECHO.

TEAR THE EDGES OF THIS PAGE RANDOMLY WITHOUT TEARING OUT THE PAGE.

Make something out of toothpicks on these pages. Name your design.

DRAW MOUNTAINS ON THIS PAGE AND TITLE IT "YOU CAN DO IT!"

FILL THIS PAGE WITH ENCOURAGING QUOTES
THAT REMIND YOU HOW STRONG YOU ARE.

Add
some
texture
to
this
page
using
paperclips
and
rubber
bands.
Think
outside
the
box.

CREATE YOUR DREAM BOARD ON THIS PAGE USING MAGAZINE CLIPPINGS.

WRITE YOUR FAVORITE MOVIE HERE. WRITE
MEMORABLE SAYINGS FROM THE MOVIE ON
THIS PAGE, TOO. USE BLUE INK.

GIVE THIS PAGE A MAKEOVER USING LIPSTICK, EYELINER AND OTHER VARIOUS MAKEUP PRODUCTS. MAKE IT PAPARAZZI READY.

TURN THIS PAGE INTO WHAT YOU SEE WHEN YOU LOOK THROUGH A KALEIDOSCOPE.

MAKE A ROADMAP TO PLACES THAT DON'T EXIST. NAME ROUTES, CITIES, AND LANDMARKS. BE CREATIVE.

WRITE A "ROSES ARE RED" POEM HERE.
YOU MUST CREATE THE POEM.

GET THIS PAGE
CAUGHT IN A
ZIPPER.

Create "PETAL POWER" pages. Press, dry, and preserve several

types of flower petals here. Then gently paste them on the page.

Turn this page into a troll, gnome or fairy with watercolors!

MAKE A RAINBOW OF WRISTBANDS ON THIS SPREAD.

COLLECT AND KEEP WRISTBANDS FROM PLACES YOU VISIT
LIKE PARKS, PARTIES, MUSEUMS, ETC.

Create your own
MAD LIBS

**Share it with family and friends and see
all of the different answers you get.**

DO SOMETHING WITH SPONGES ON THESE PAGES.

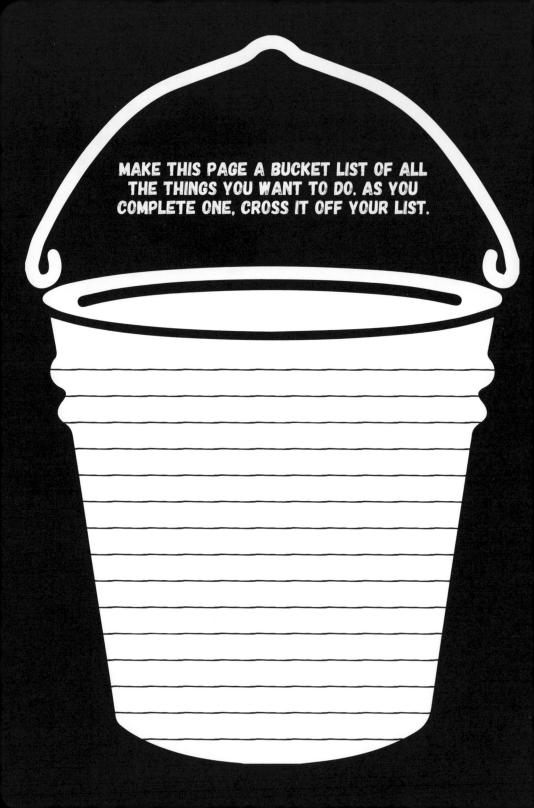

MAKE THIS PAGE A BUCKET LIST OF ALL THE THINGS YOU WANT TO DO. AS YOU COMPLETE ONE, CROSS IT OFF YOUR LIST.

Blow **BUBBLES** on these pages.

WASH YOUR HAIR WITH SHAMPOO AND
THEN RUB THE LATHER ON THIS PAGE.
WRITE THE NAME OF THE SHAMPOO
IN THE CENTER.

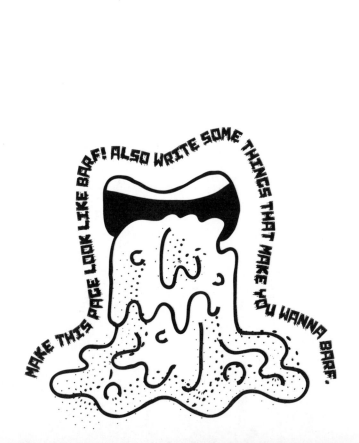

MAKE THIS PAGE LOOK LIKE BARF! ALSO WRITE SOME THINGS THAT MAKE YOU WANNA BARF.